DRAWING MONSTERS
With Letters 2

Created by

STEVE HARPSTER

HARPTOONS
PUBLISHING

This book is dedicated to the imagination of kids everywhere.
The art and drawings of children inspire and challenge me to
look at the world in a new way.
 -Steve Harpster

www.harptoons.com

Library of Congress Cataloging-in-Publication Data
Library of Congress Control Number: 2015901898
Harpster, Steve
Drawing Monsters With Letters 2 / written and illustrated by Steve Harpster

SUMMARY: Learn how to draw monsters starting with a letter.
ART / General, JUVENILE FICTION / General

ISBN: 978-0-9960197-2-9
ISBN: 0-9960197-2-3

SAN: 859-6921

**For school visits and art programs please go to www.harptoons.com
or contact Steve Harpster by email at steve@harptoons.com**

Follow Harptoons on:

Welcome to *Drawing Monsters With Letters 2*. What's different about this book? Well for one more pages and more monsters to draw. Also, you might notice this icon on some of the pages.

This means I have a video of me drawing the monster at Harptoons.com. So grab your pencil and some paper and turn on your imagination, and let's draw some monsters.

Happy Drawing!

STEVE HARPSTER

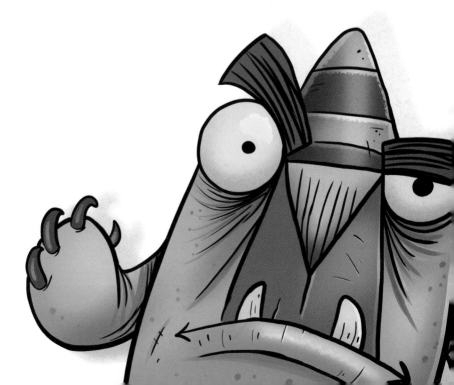

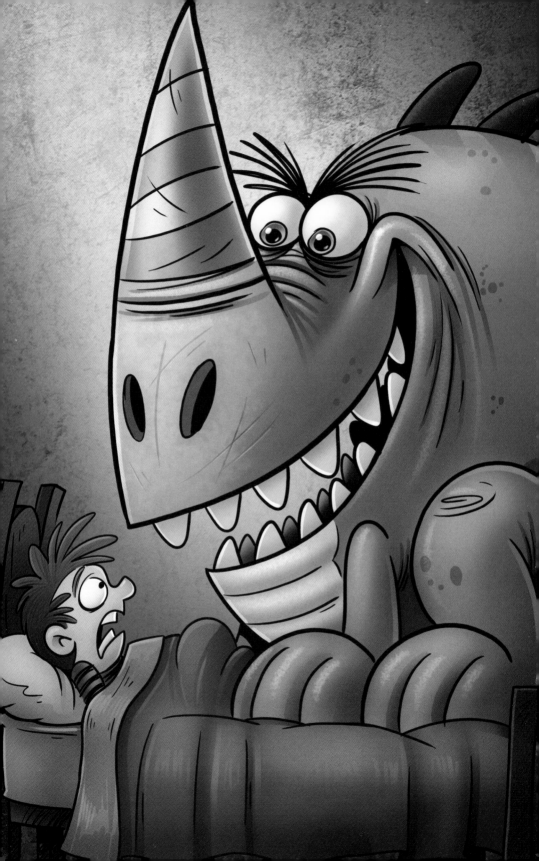

Arrg

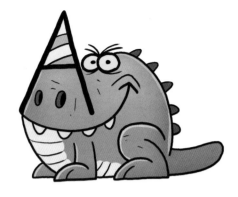

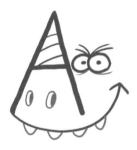

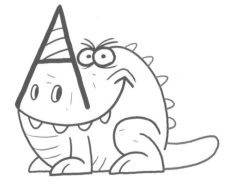

Blarg

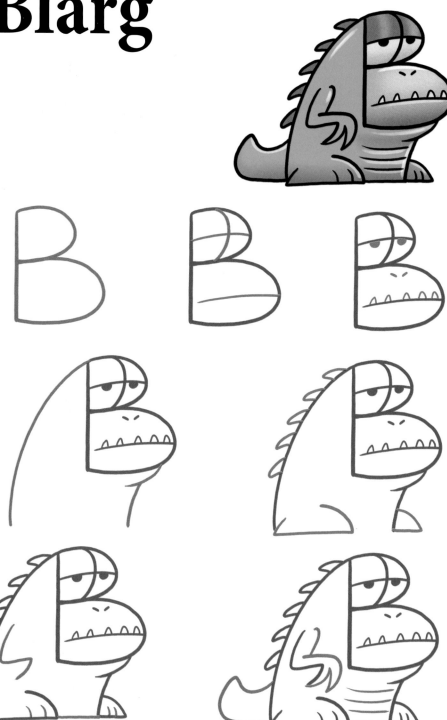

Crug

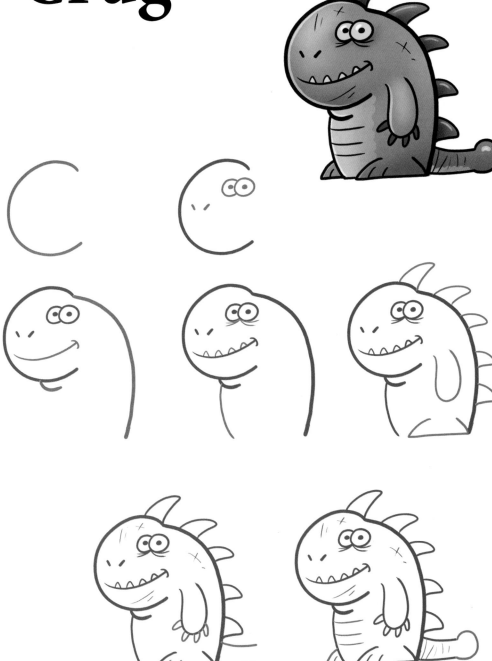

Carbog

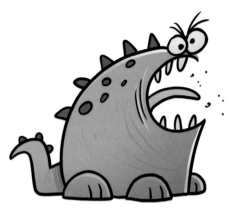

Dun-Dog

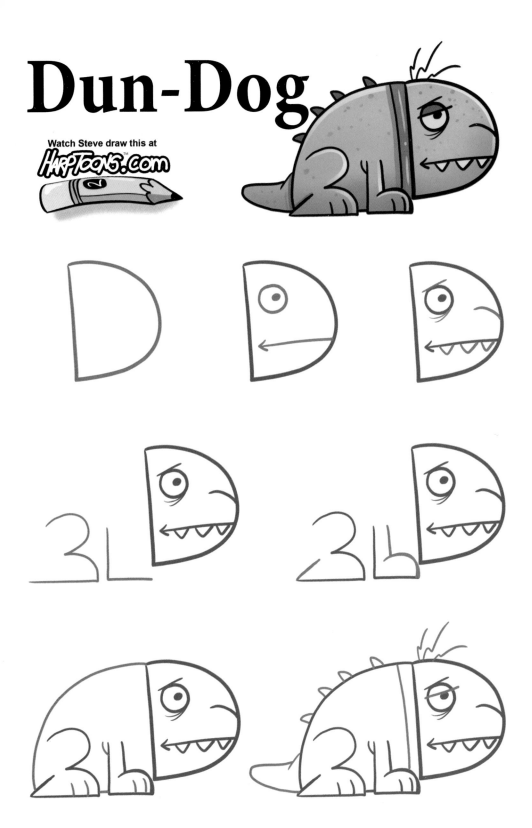

Dirge

Egard

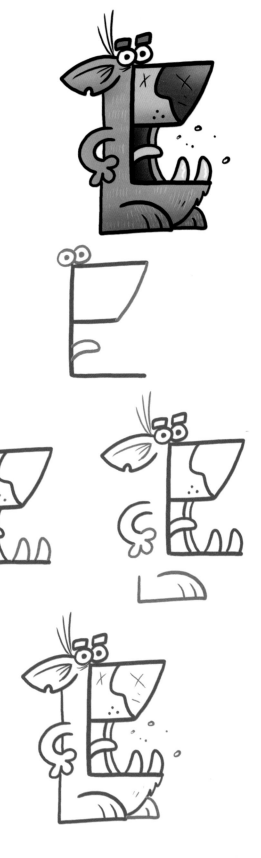

Fang

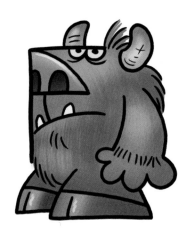

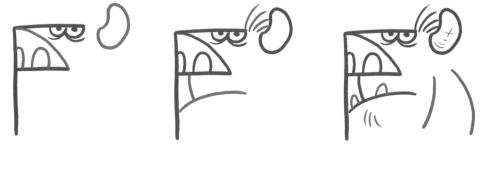

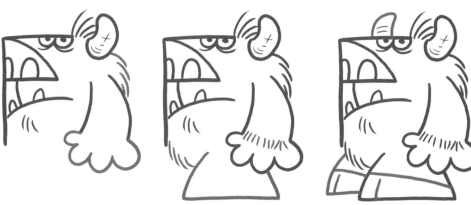

Frunk

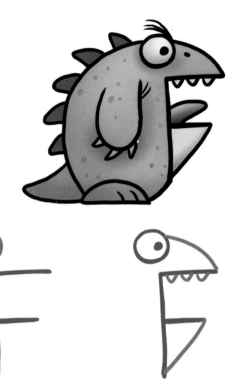

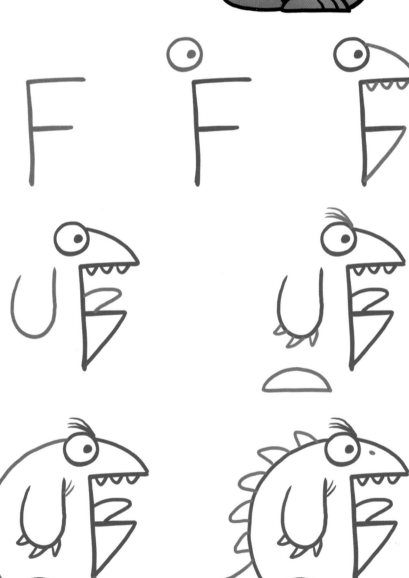

Grub

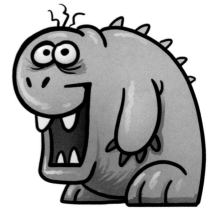

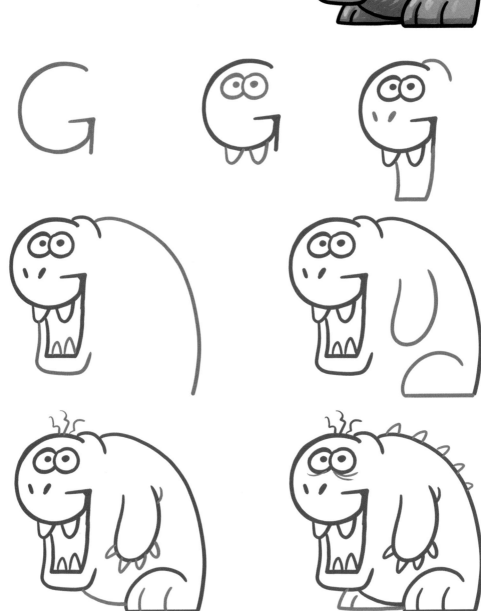

Horace

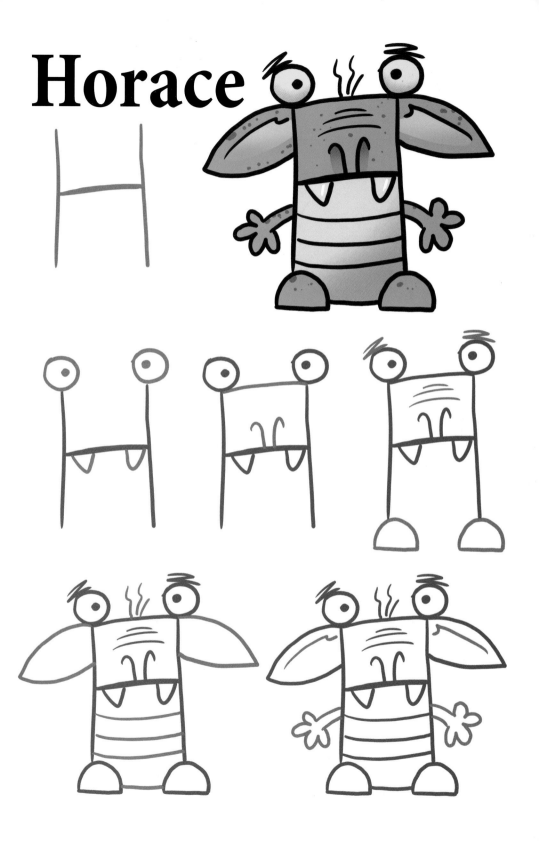

Horton

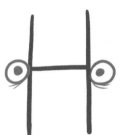
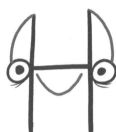

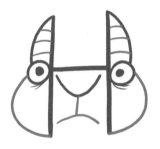

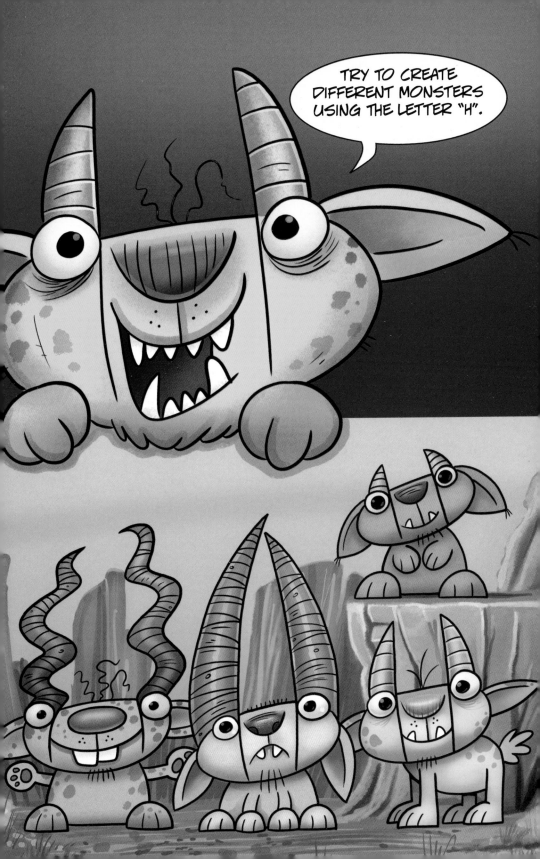

Igle

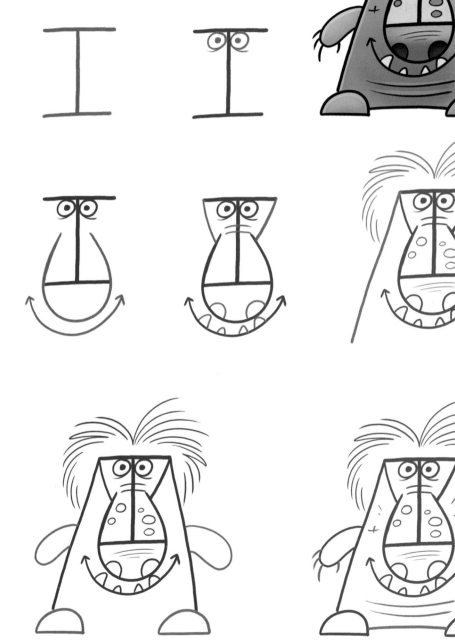

Jub-Jub

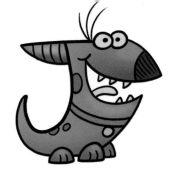

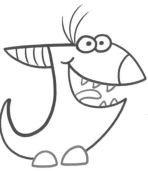

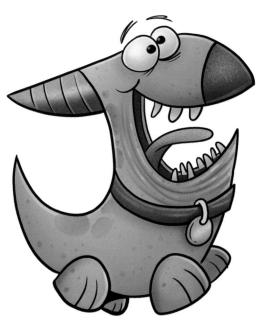

Kogar

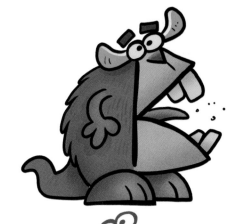

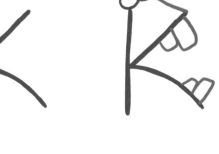

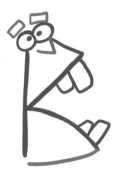

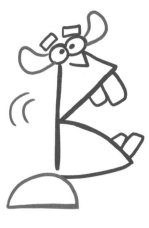

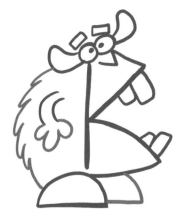

Klorn

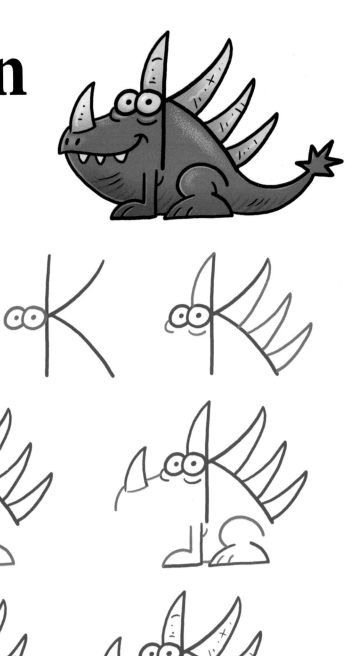

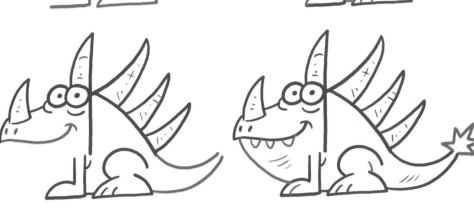

Leech

Mort

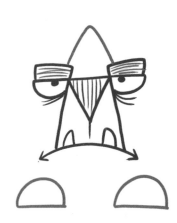

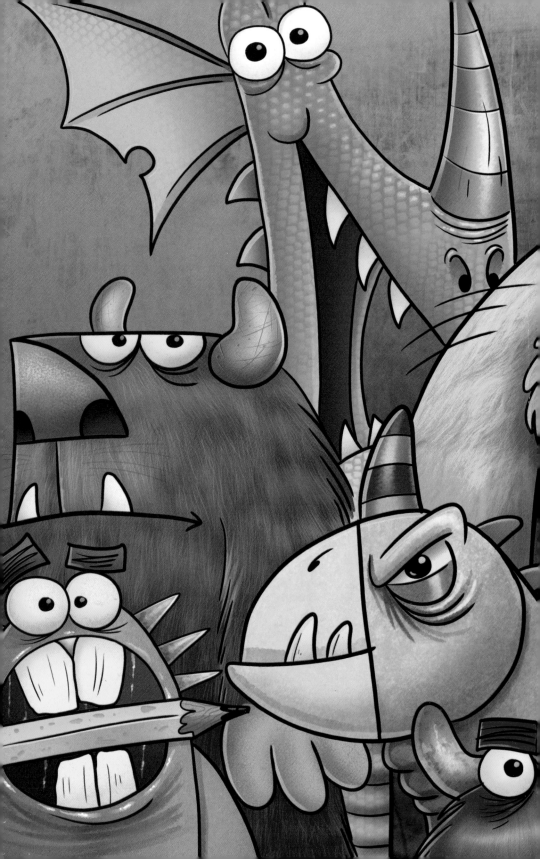

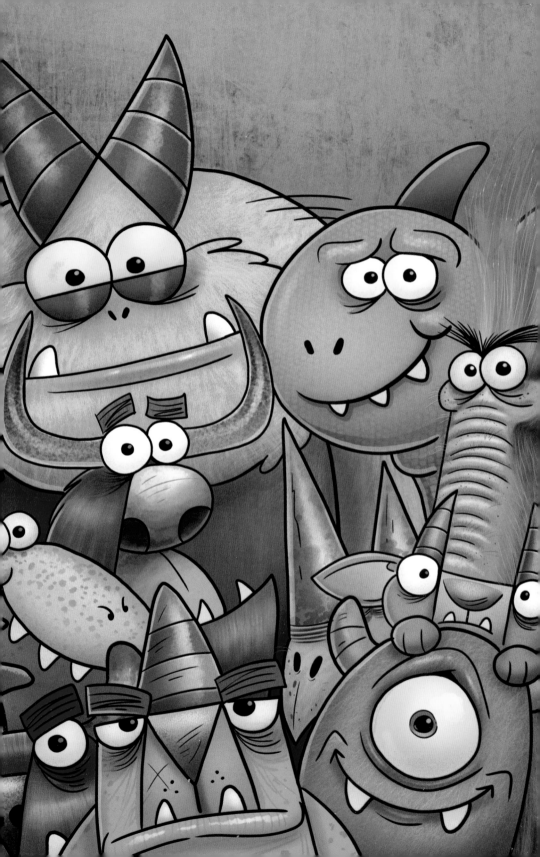

Ness E

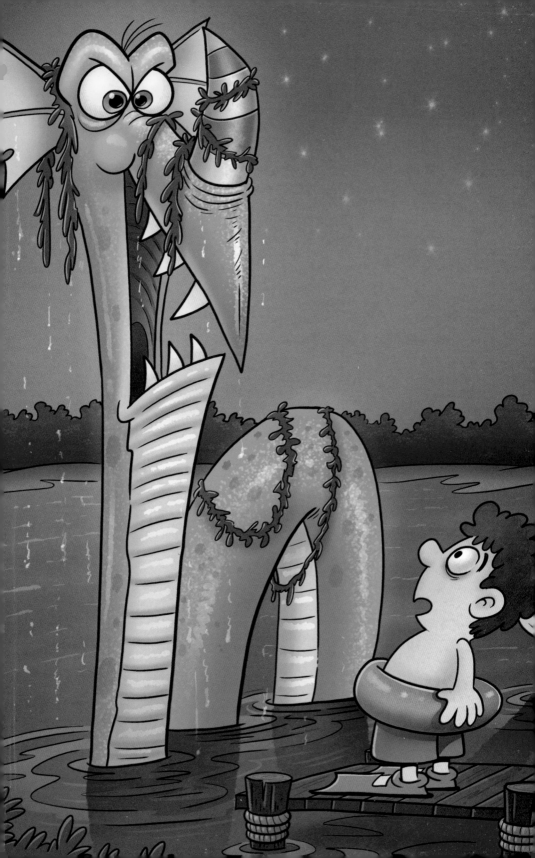

Ooozle

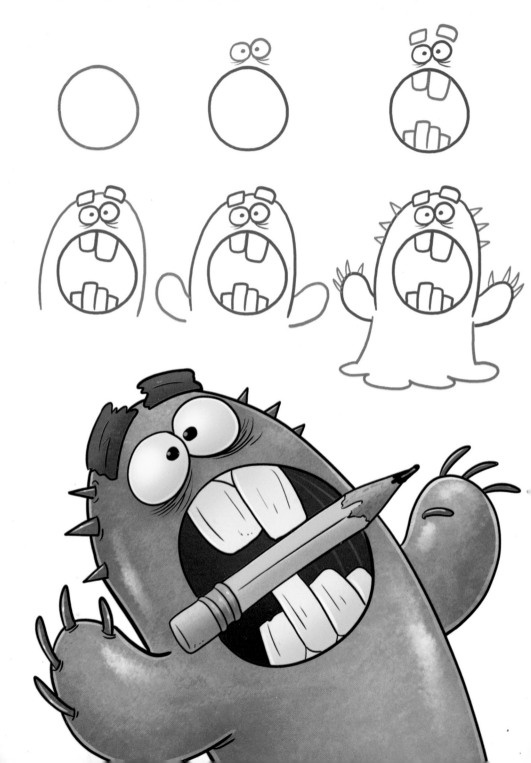

Opto

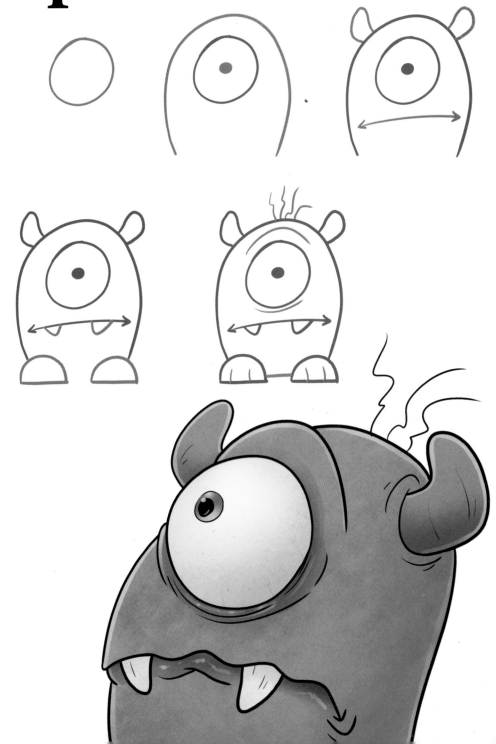

Plug

Watch Steve draw this at

HARPTOONS.com™

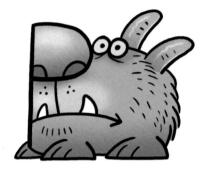

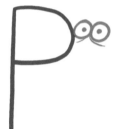

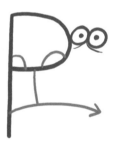

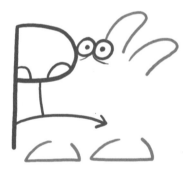

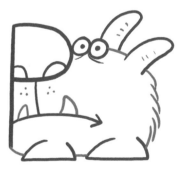

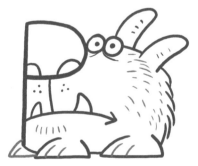

Quig

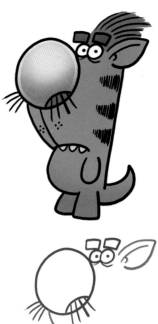

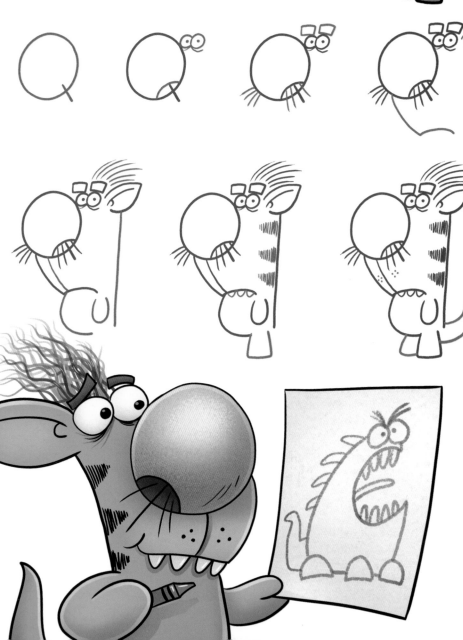

Rock

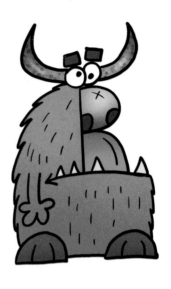

Snarg

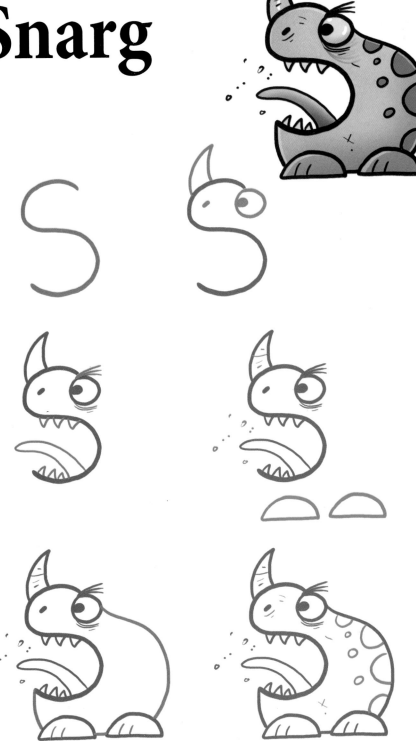

Sluggo

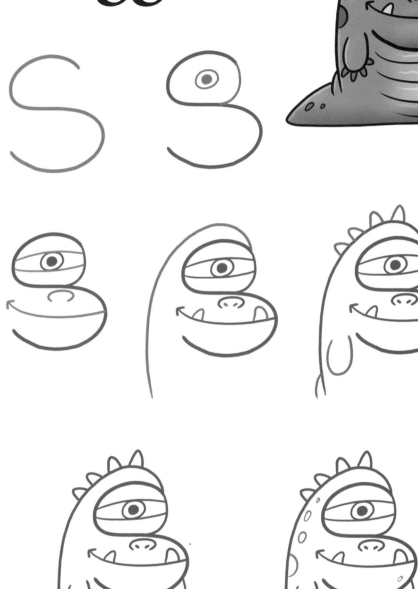

Tork

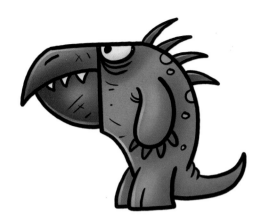

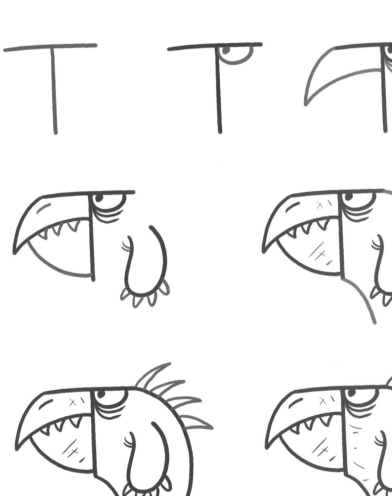

Urp

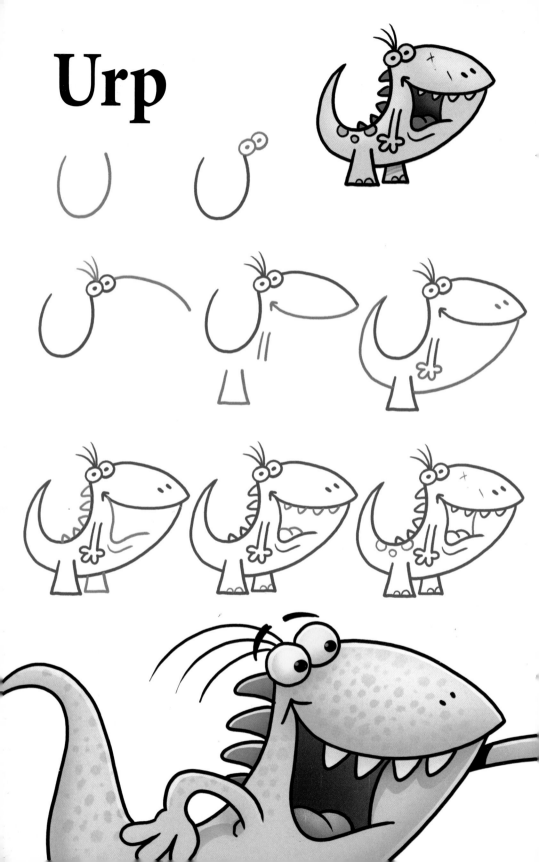

Vurg

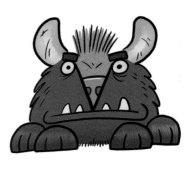

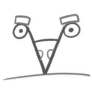

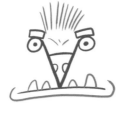

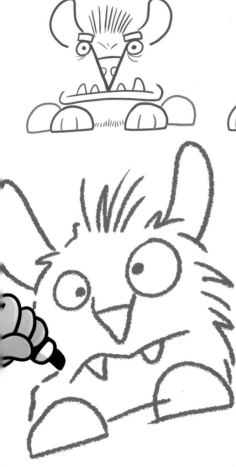

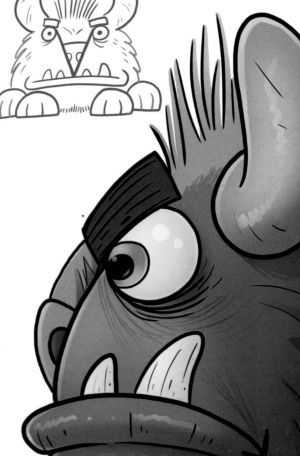

Warg

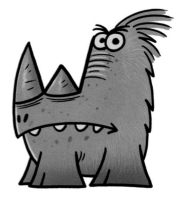

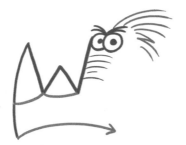

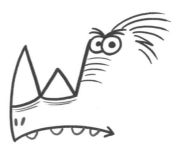

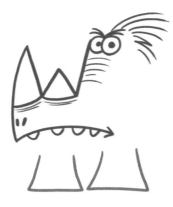

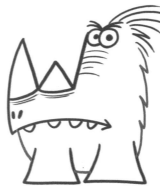

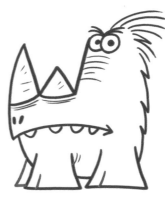

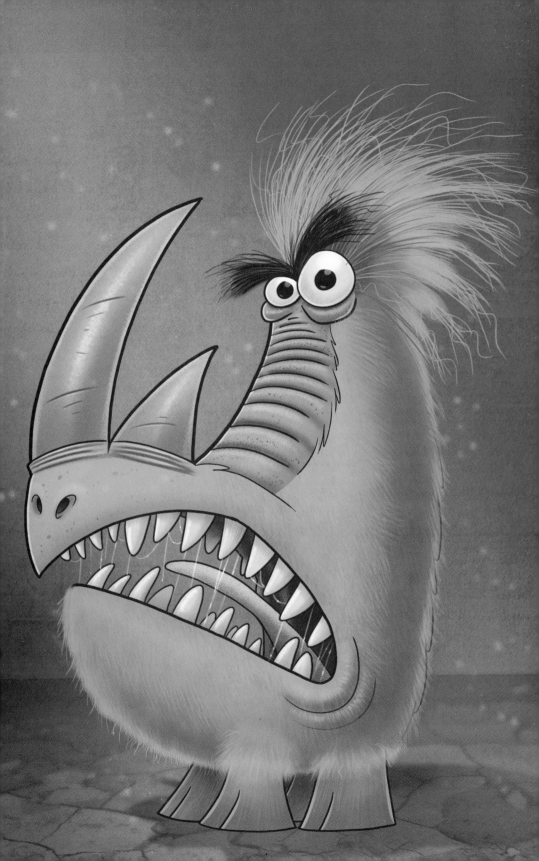

Wyatt

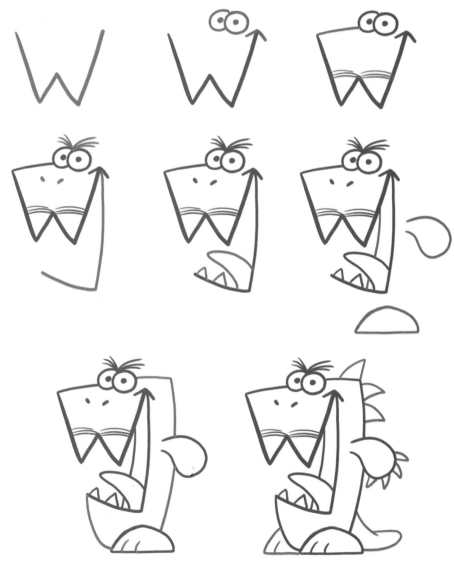

Xark

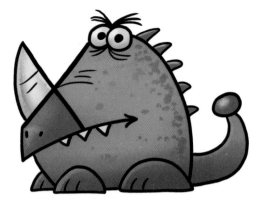

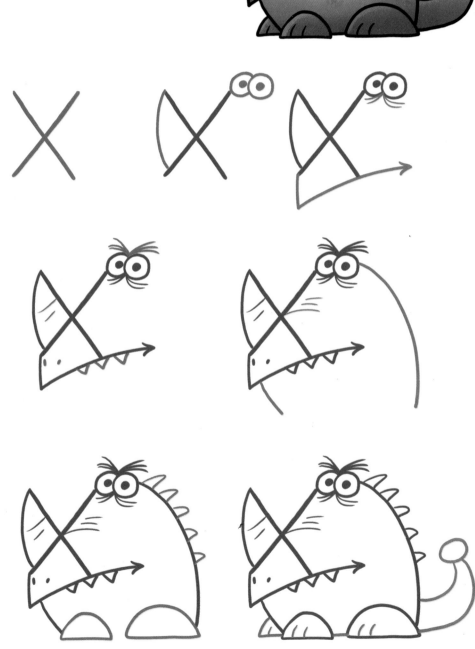

Xog

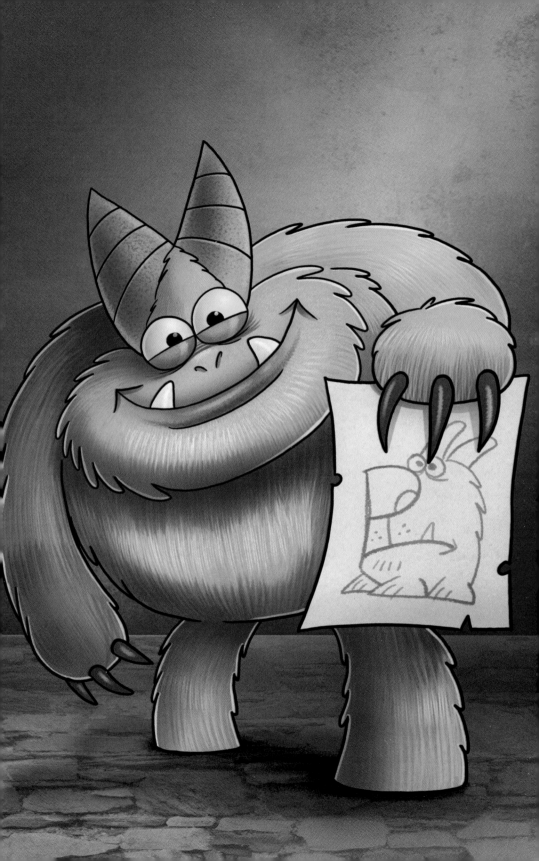

Yuk

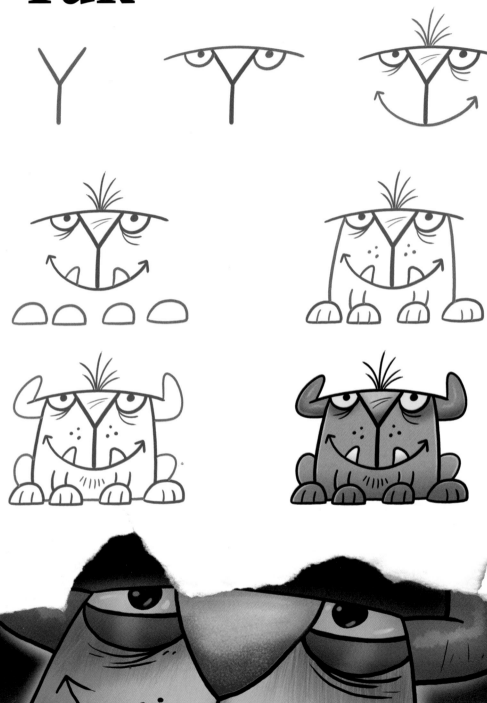

Zerk

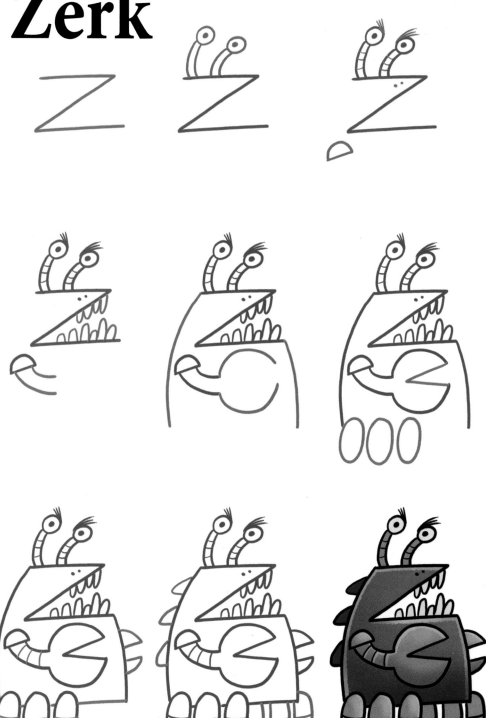

Create a MONSTER WORLD

HERE IS HOW TO EASILY CREATE A WORLD FOR YOUR MONSTERS TO LIVE IN.

PAINT SOME FUN SHAPES USING WATERCOLOR PAINTS.

USE A PEN TO DRAW LINES TO DEFINE SHAPES.

Watch Steve draw this at HffpToonS.com

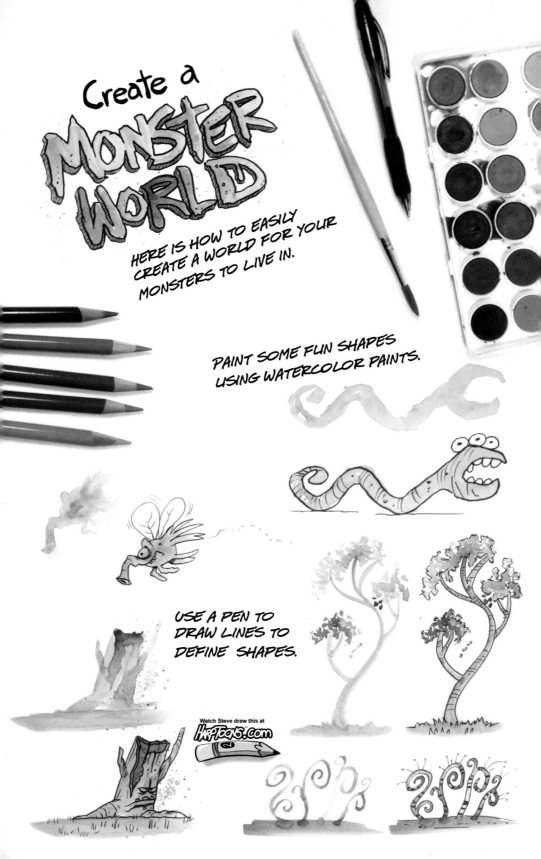

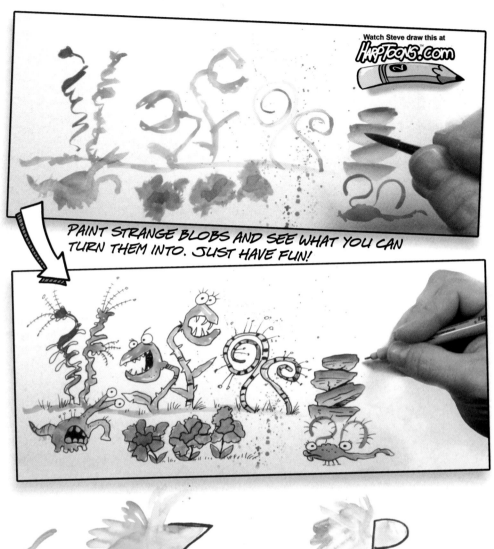

PAINT STRANGE BLOBS AND SEE WHAT YOU CAN TURN THEM INTO. JUST HAVE FUN!

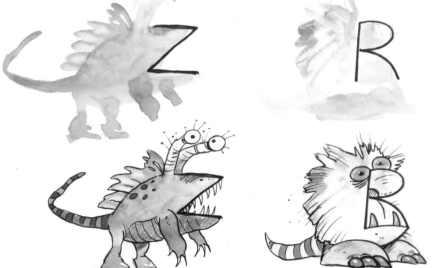

TRY PAINTING OVER A LETTER. SEE IF YOU CAN CREATE YOUR OWN FUN MONSTERS. USE MARKERS AND COLORED PENCILS TO ADD DETAILS AND COLOR TO YOUR MONSTER.

Visit Harptoons.com and watch how-to-draw videos, print off FREE coloring and activity pages, and create fun crafts. Mail your drawings to Harptoons.com and you might see it in featured in the Art Show. All this and more at the greatest drawing site dedicated to getting young people drawing, creating and imagining.

Follow Harptoons on: